KOI

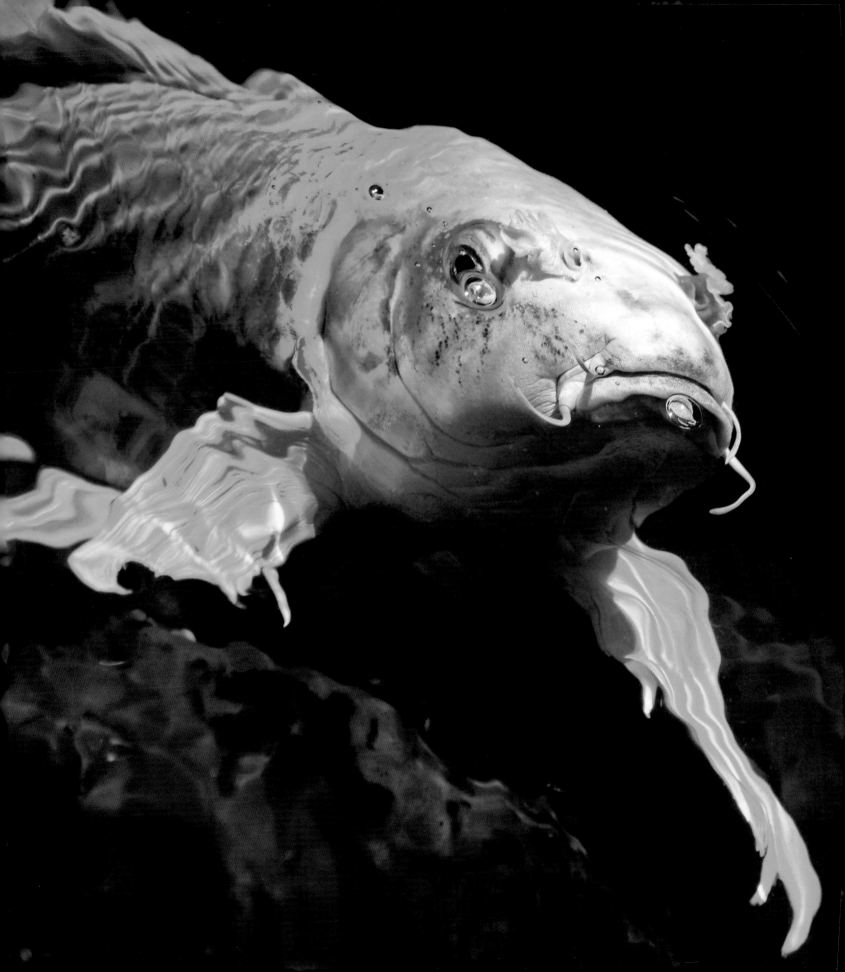

KOI
A MODERN FOLKTALE

PHOTOGRAPHS BY MARGERY GRAY HARNICK AND MATT HARNICK

HAIKU NARRATIVE SEQUENCE BY SHELDON HARNICK

BEAUFORT BOOKS

FIRST EDITION

Library of Congress Cataloging-in-Publication Data on file
ISBN: 978-082530841-3

For inquiries about volume orders, please contact:
Beaufort Books
27 West 20th Street, Suite 1102
New York, NY 10011
sales@beaufortbooks.com

Published in the United States by Beaufort Books
www.beaufortbooks.com

Distributed by Midpoint Trade Books
www.midpointtrade.com

Printed in China

Design by Pauline Neuwirth, Neuwirth & Associates, Inc.

We happily dedicate this book to our cherished

siblings: Dorothy Gray Delong (Margie's sister), Beth

Harnick Dorn (Matt's), and Jay Harnick and Gloria

Harnick Parloff (Sheldon's brother and sister).

Their enthusiasm and encouragement

for Koi were a constant inspiration.

Our profound thanks to Megan Trank, Managing Editor

of Beaufort Books, for responding so quickly and

so positively to the photographs and verses of Koi.

Our equally profound thanks to Pauline Neuwirth for

designing this book so artfully. And our most profound

thanks to Jasmine Gabay Kimball for allowing Margery

to photograph the exquisite creatures in her koi pond.

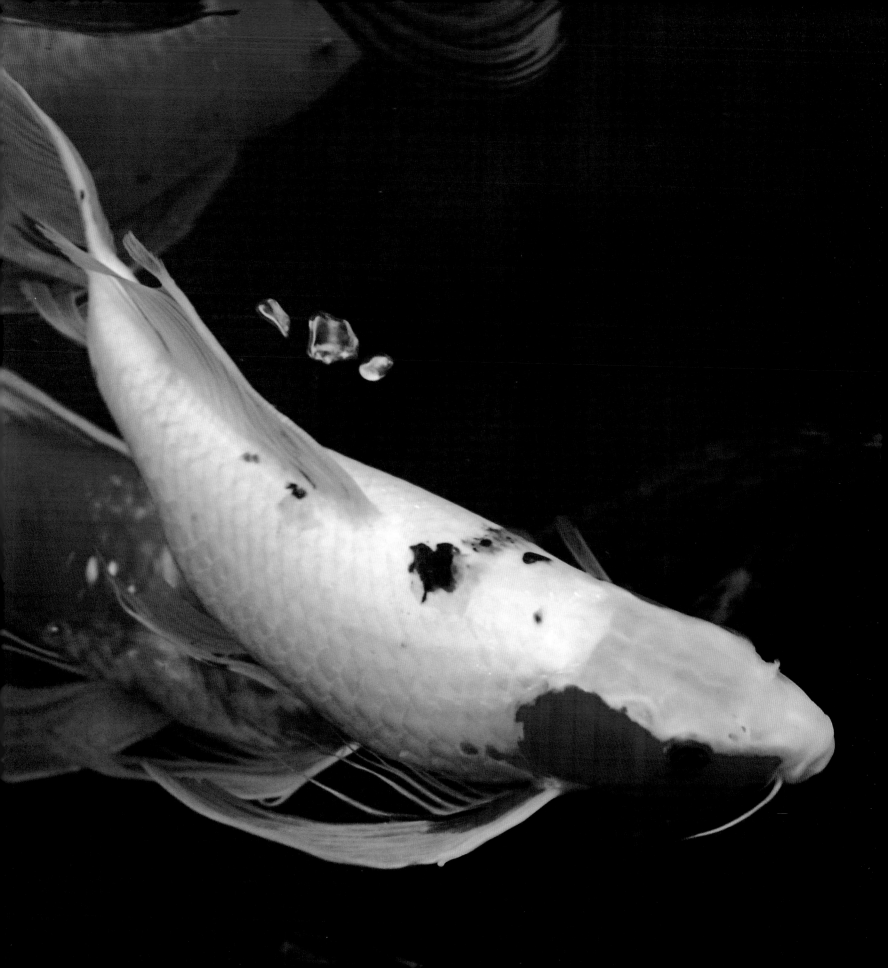

FOREWORD

ALAN ALDA

From their book's first image of an amazing creature

looking you straight in the eye with uncanny power, you

realize that Margery Harnick and her son Matt are not going to give you

photos of happy little fishies. They have something deeper, something

more transformative in mind. It's true that in the book's narrative poem

by Sheldon Harnick, the koi delight people as they squirt through

the water, but the tale only begins there. They're so *good* at giving

us pleasure that the gods reward them by making them dragons with

the power to protect humanity. They go in a natural progression, from

giving pleasure to sustaining life.

I think Sheldon's songs and lyrics occupy a special circuit in all our

brains. So many of his songs urge us on, just as the gods urge on the koi, first

to engage in the pleasures of life, but also to be mindful of protecting and

sustaining life itself. In *Fiddler on the Roof*, in his vigorous hymn *To Life*, he

vaccinates us against the left turns that life can take and sustains us with wit:

"To us and our good fortune! . . . And if our good fortune never comes, here's

to whatever comes . . . !"

He not only gives us pleasure, he gives us strength and protects us.

(So Sheldon himself is a koi!) He's delighted us for more than half a century,

sprinkling us with the refreshing spray of pleasure. And early on, the gods said,

"This koi needs to be a dragon!"

Like Sheldon's words in this book, the photographs by Margie and Matt

take us from a simple but vivid reality to a sense of something larger: they

give us another way of seeing. They give us another world. Their

photographs are vibrant, alive, and startling. These fish have character.

We know people like this. And at the same time, we've never seen

anything like these creatures. You might glance down at them swimming

lazily and pleasurably in a pond, but get up close and you're face to

face with dragons.

There's pleasure and wonder in seeing this transformation that

Margie and Matt create. And with their artist's eye, there's power in it,

too. Jump into the water with this happy, creative family and swim with

them toward delight and meaning.

It will be a refreshing dip.

KOI

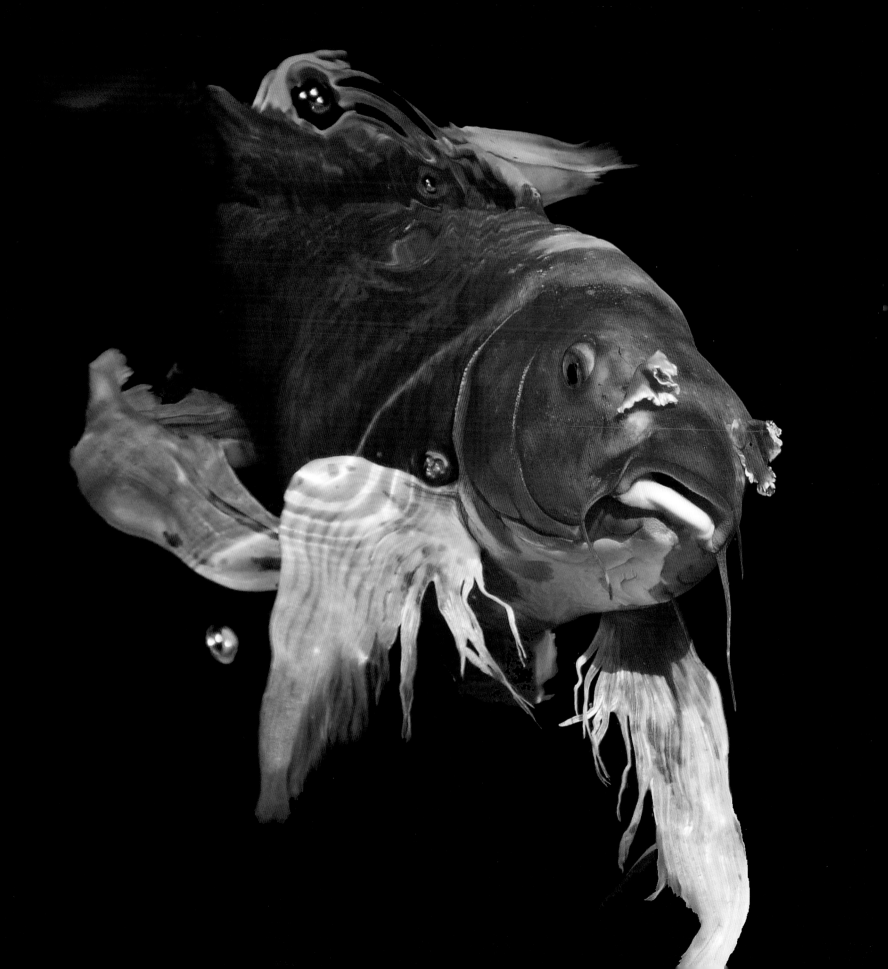

In Far Eastern streams,

there swim resplendent creatures,

golden as sunlight,

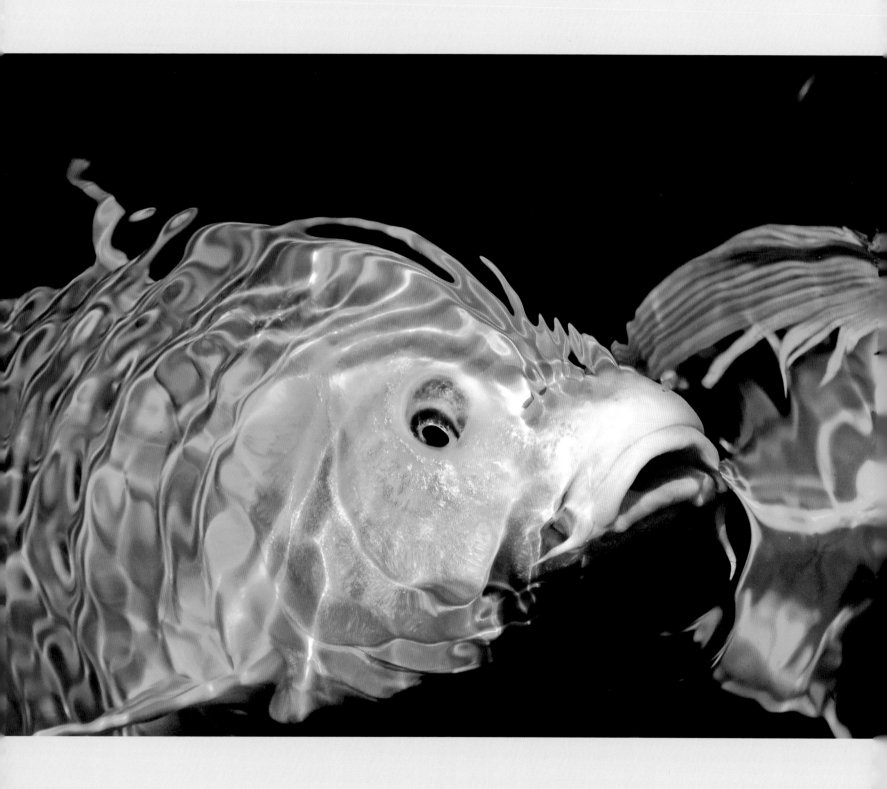

silver as moonlight,

iridescent as rainbows:

the creatures called koi.

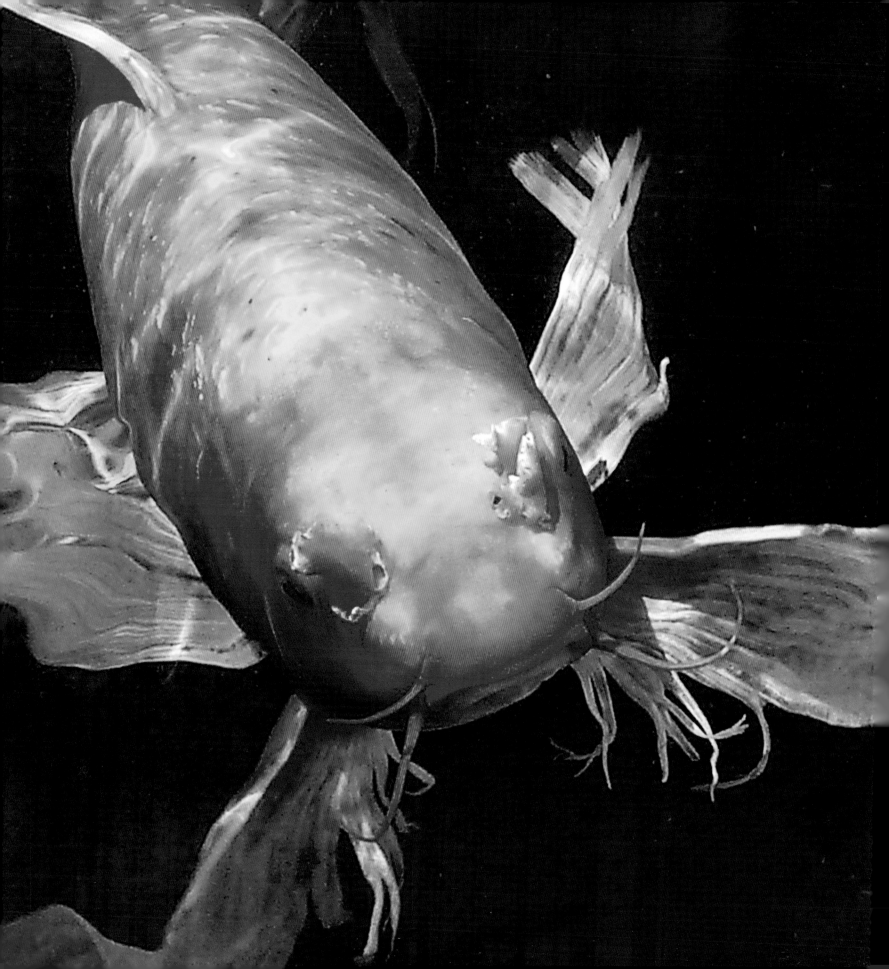

Where did they come from,

these multi-colored marvels,

Nature's *objets d'art*?

Well, carp from China

became, somehow, the wondrous

koi bred in Japan.

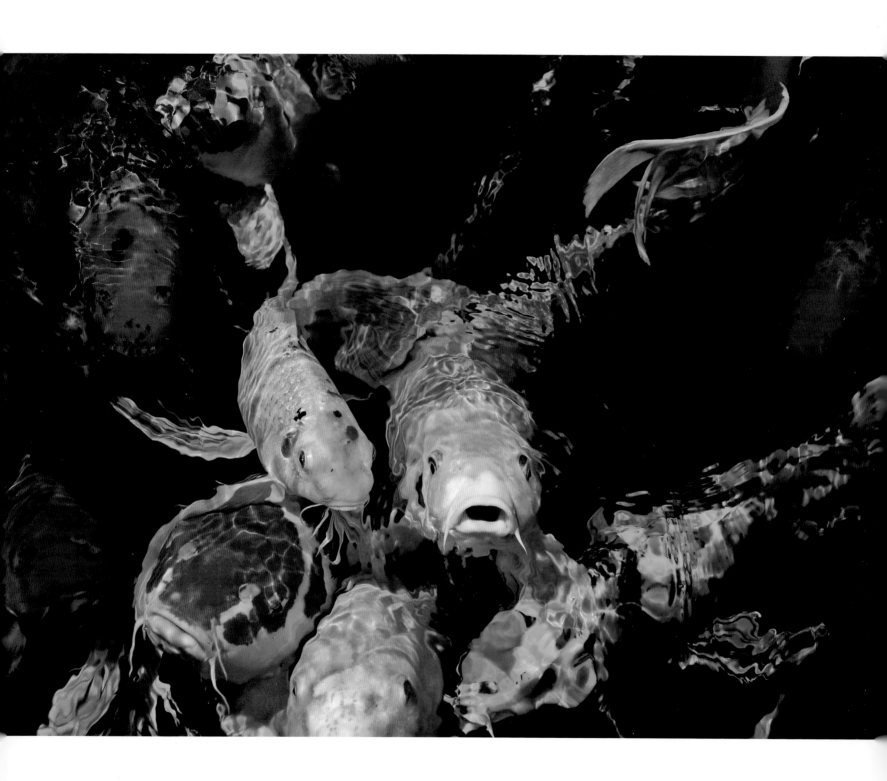

In the course of time,

some koi began to travel

to lands near and far.

And when they arrived,

whoever first beheld them

gazed in utter awe.

Never had they seen

creatures as striking as these

polychrome wonders!

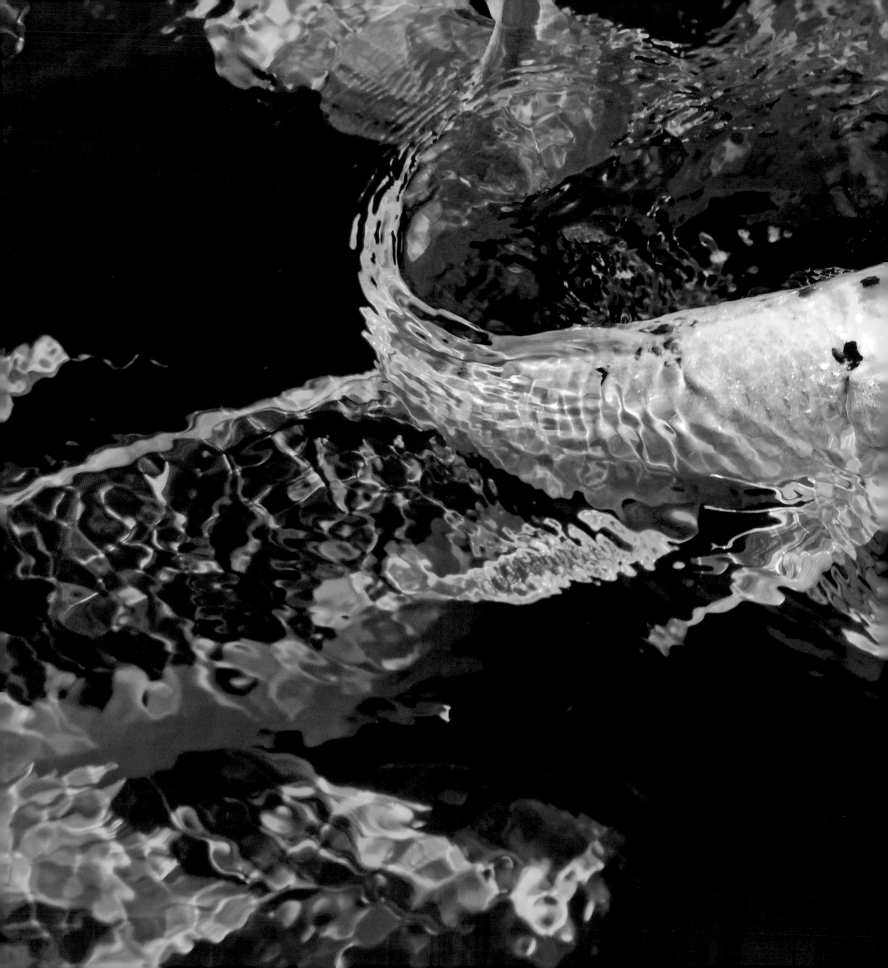

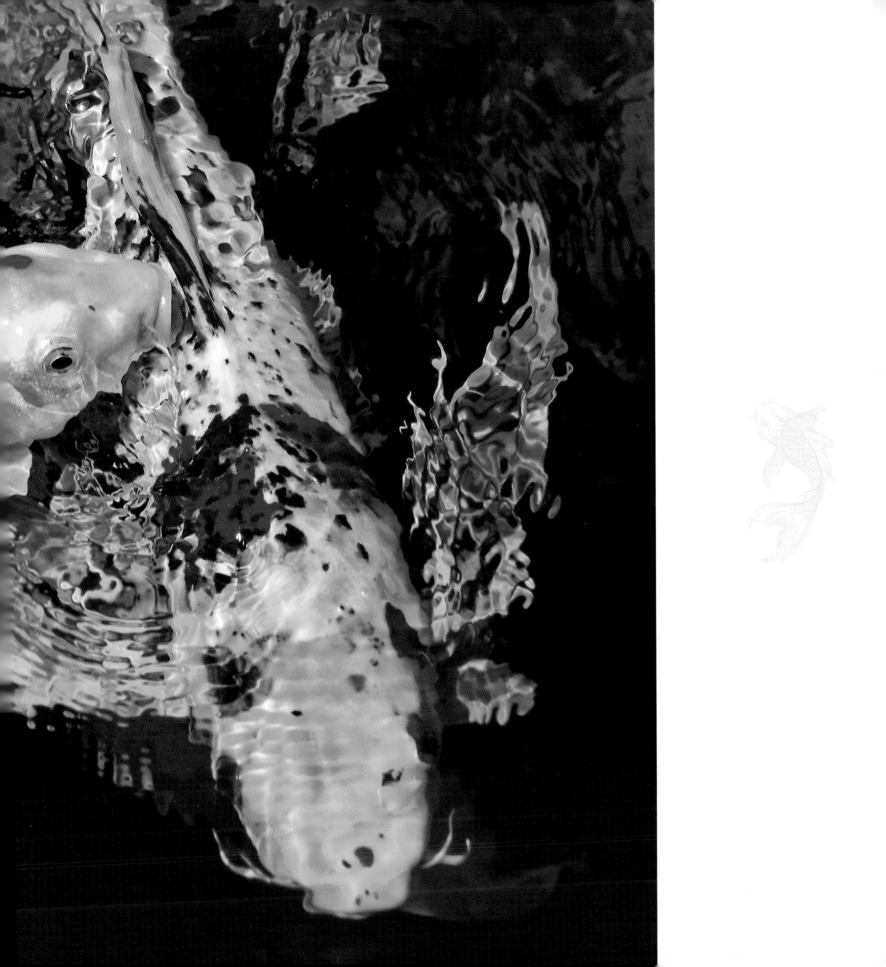

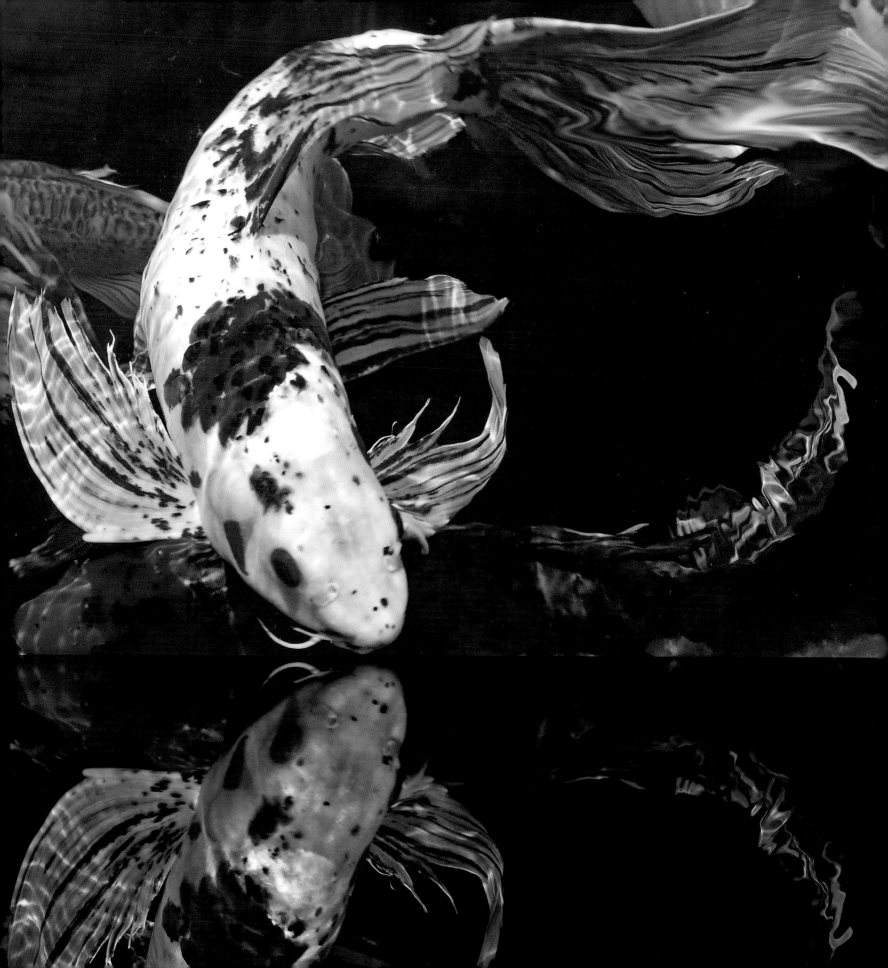

Since those first contacts,

koi have brought endless delight

to the human race.

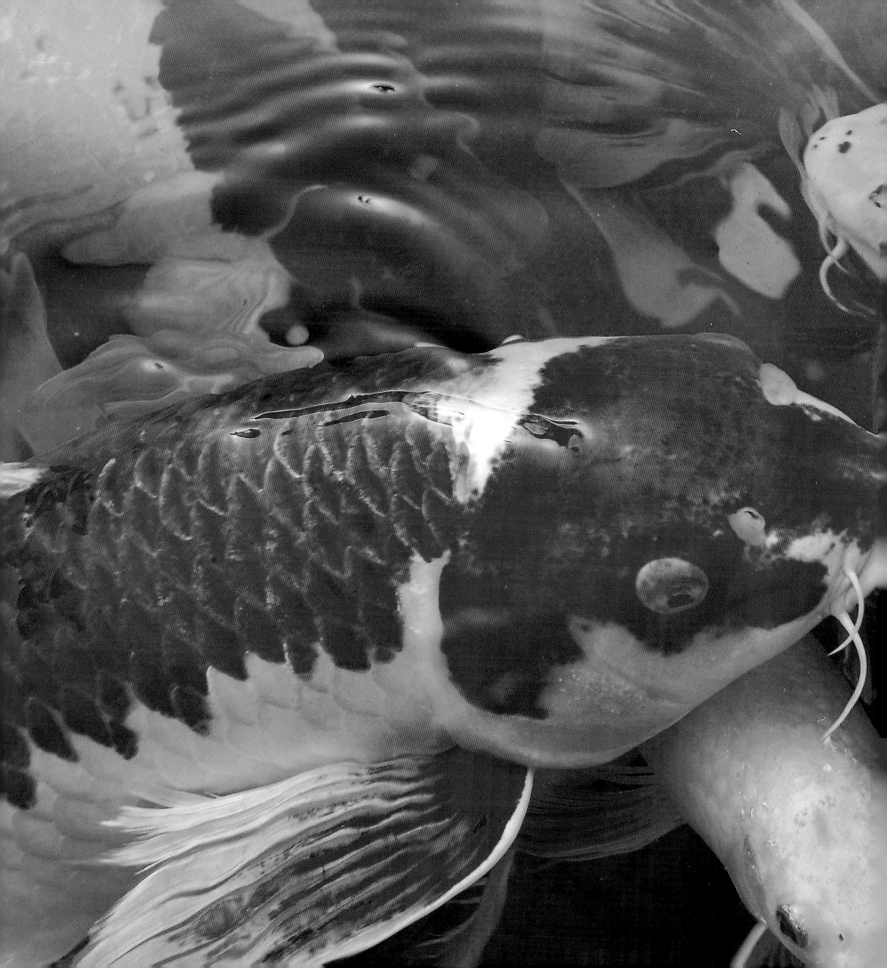

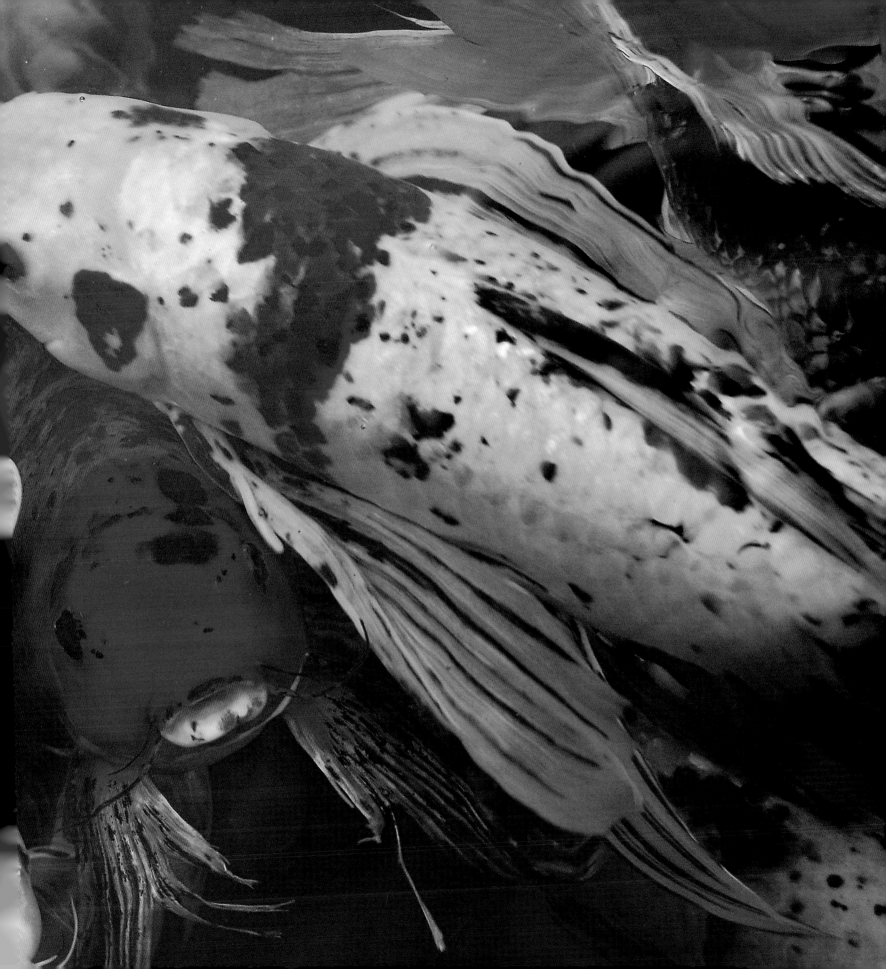

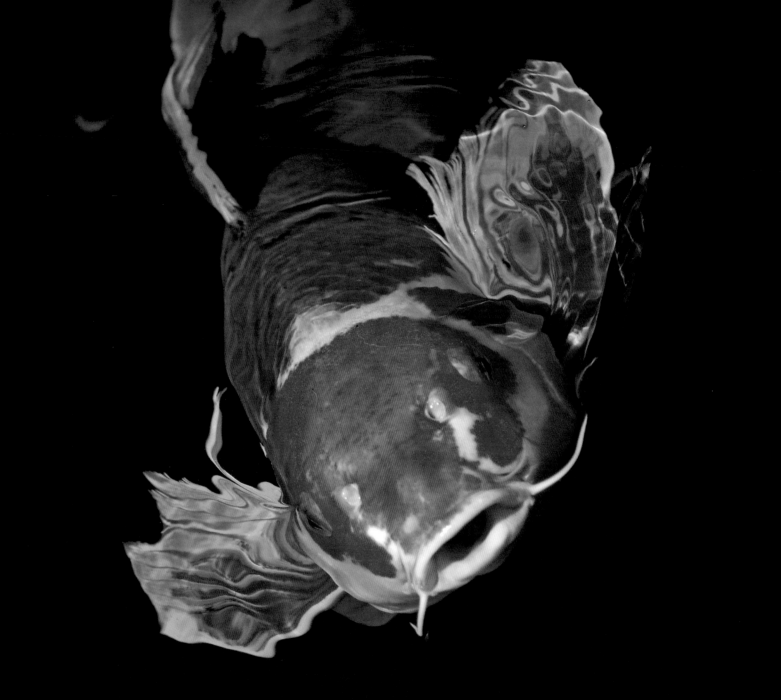

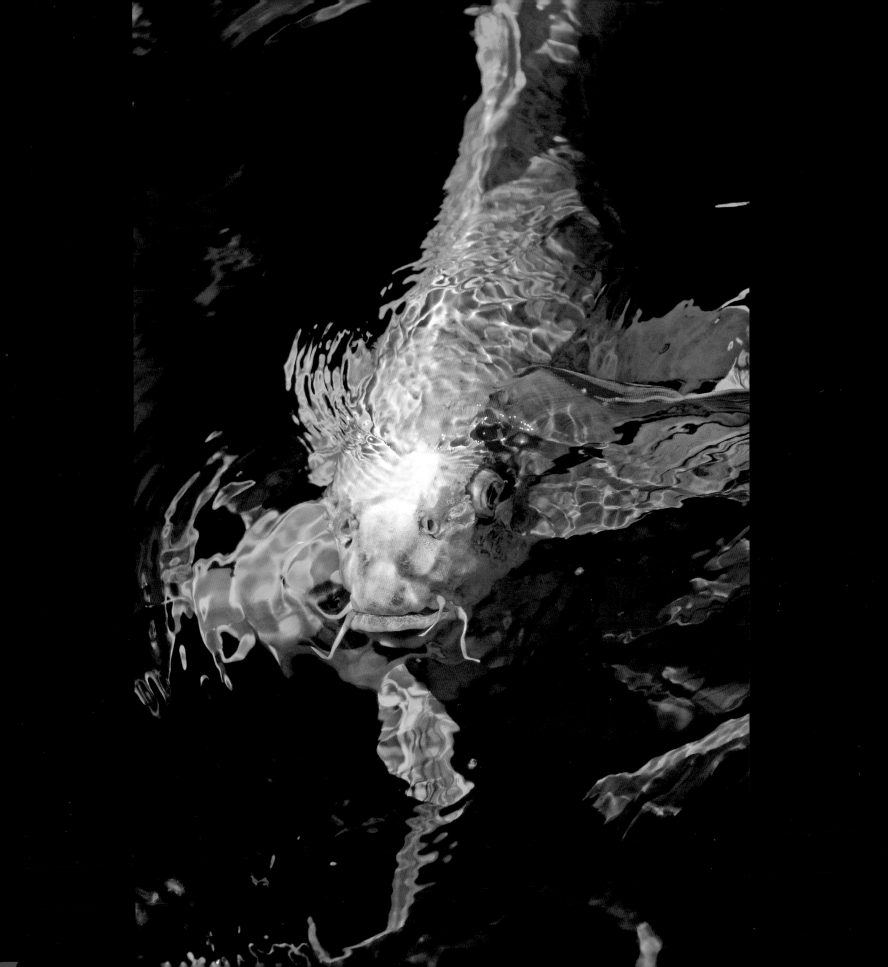

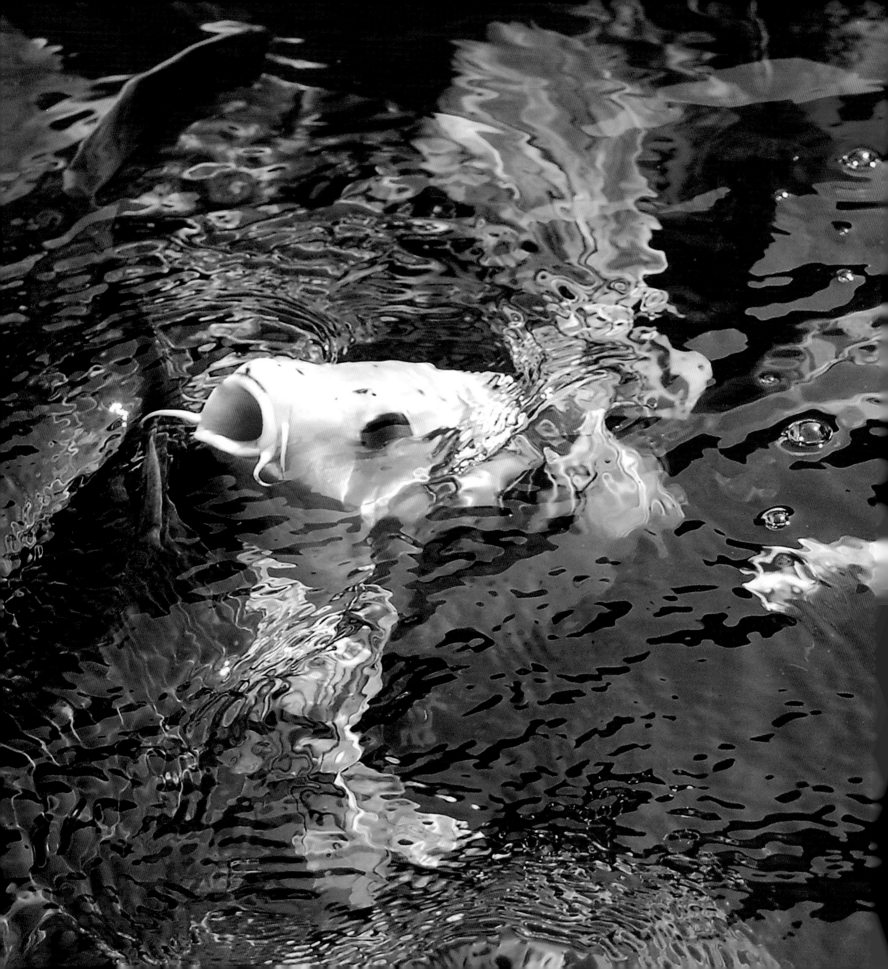

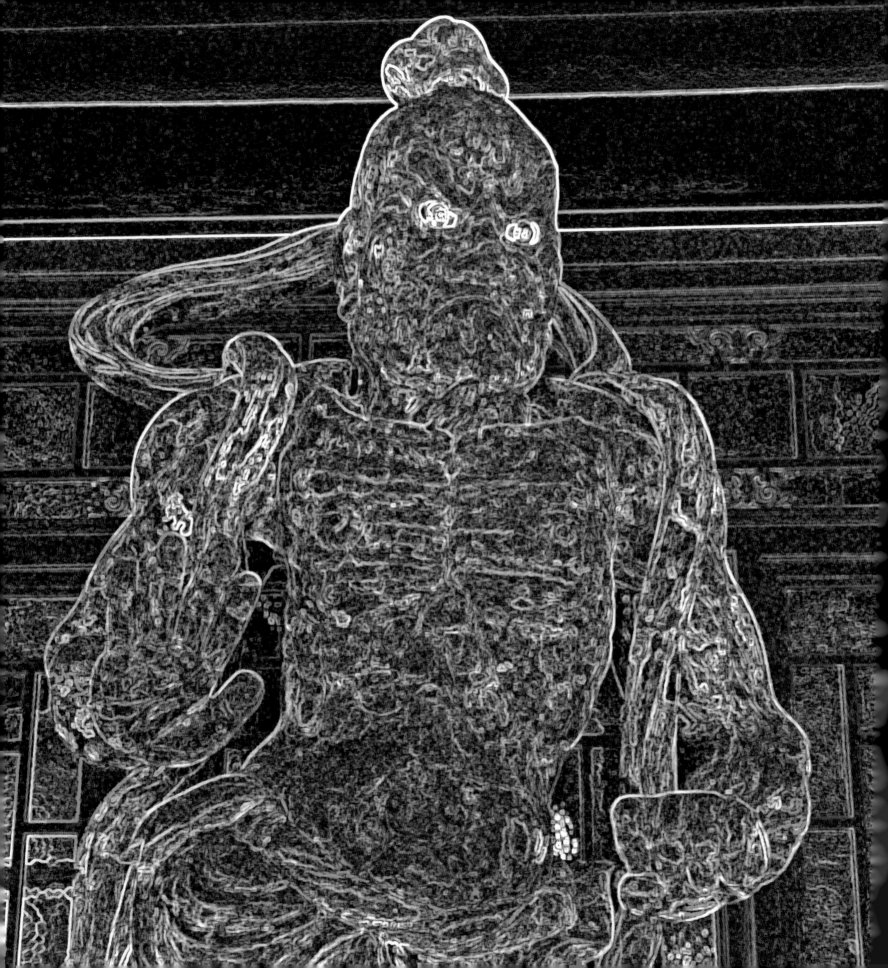

High in their heaven,

the gods pass the time watching

what transpires on earth;

and through the years, a

favorite pastime has been

observing the koi.

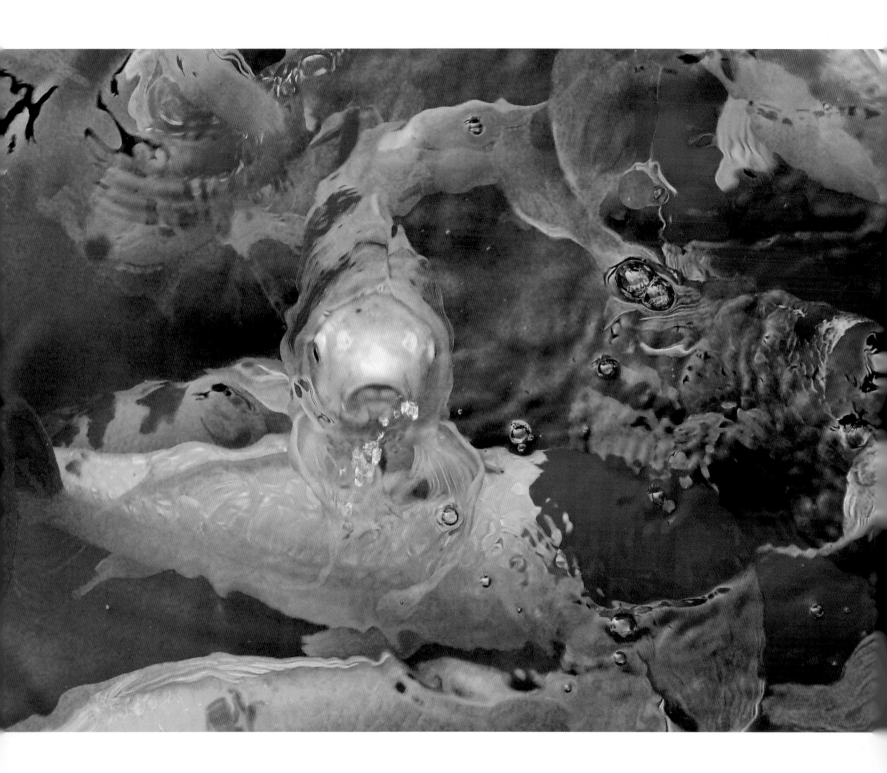

What impressed the gods

was the way in which the koi's

prismatic beauty

could brighten men's days,

as it nourished their senses,

and lightened their hearts.

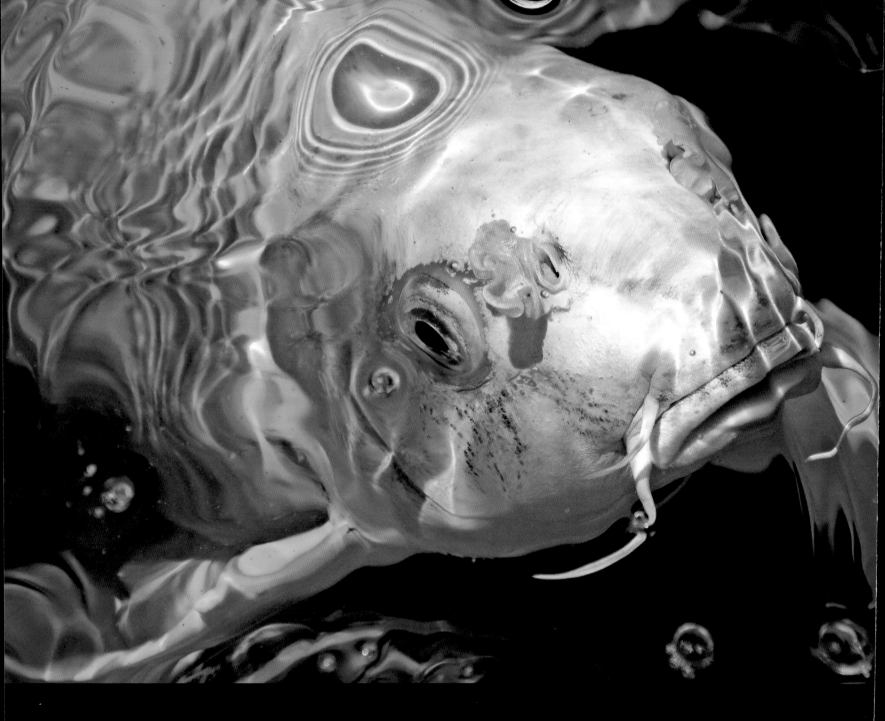

In time, the gods thought

koi should be rewarded for

enriching men's lives.

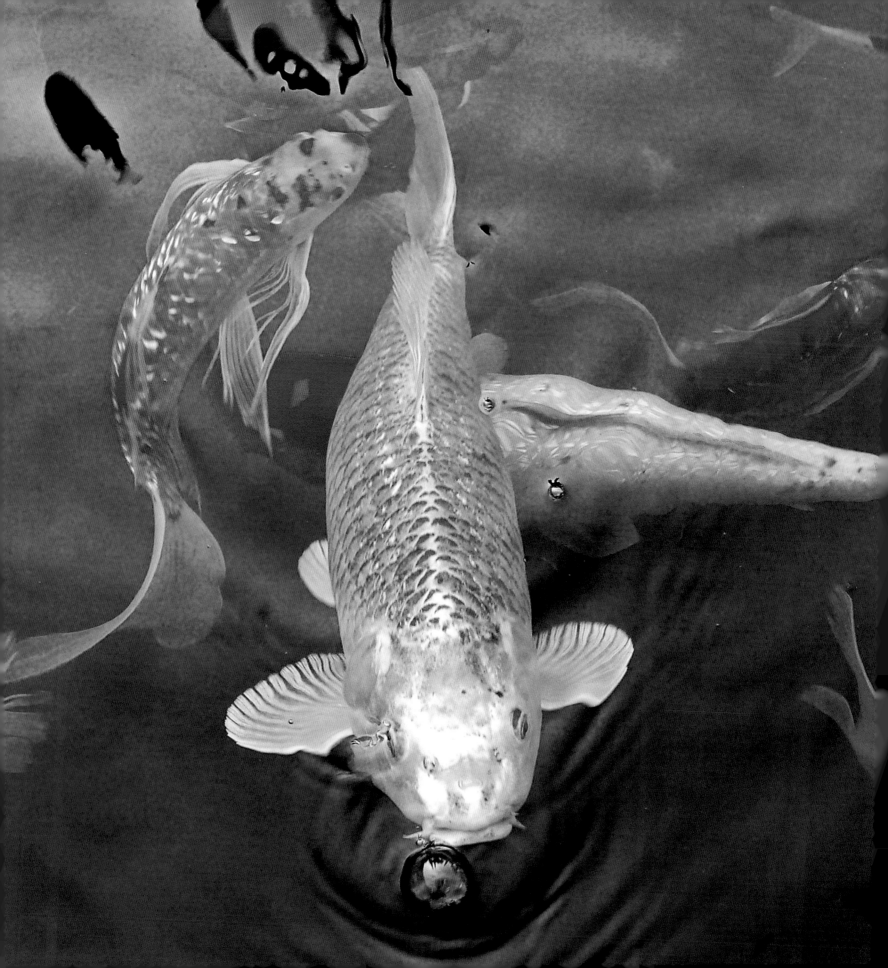

Thus did they decree:

While some koi would continue

to enchant mankind,

others would receive

by far the greatest honor

the gods could confer:

they would be transformed

from sumptuous koi into

powerful dragons

Now, the spell the gods

fabricated called for both

ionized water

and age old, arcane

incantations known only

to the gods themselves.

To complete their plan,

the gods flew down to earth

armed with thunderbolts.

Aiming carefully,

they hurled their shafts of lightning

into the rivers,

rivulets and ponds

wherein the designated

koi had made their homes.

The koi, swimming in

the electrified water,

felt some discomfort

but it soon faded

as the lengthy ritual

slowly unfolded.

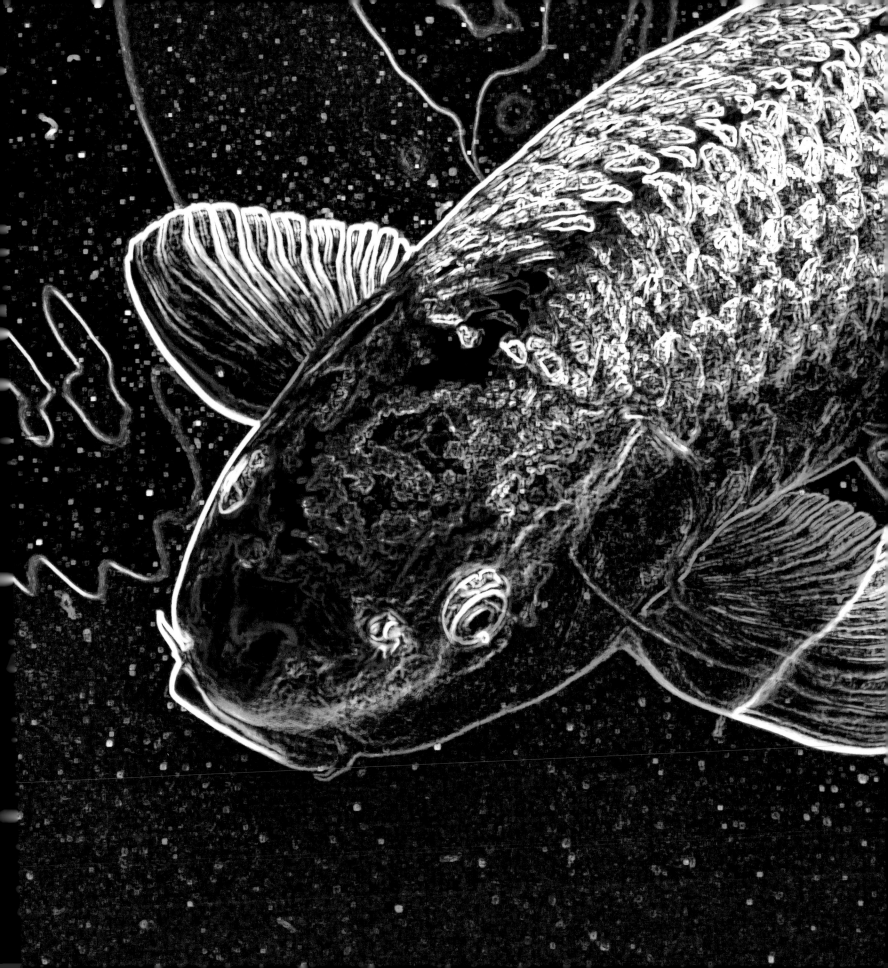

Step by mystic step,

the koi, all unsuspecting,

were being transformed.

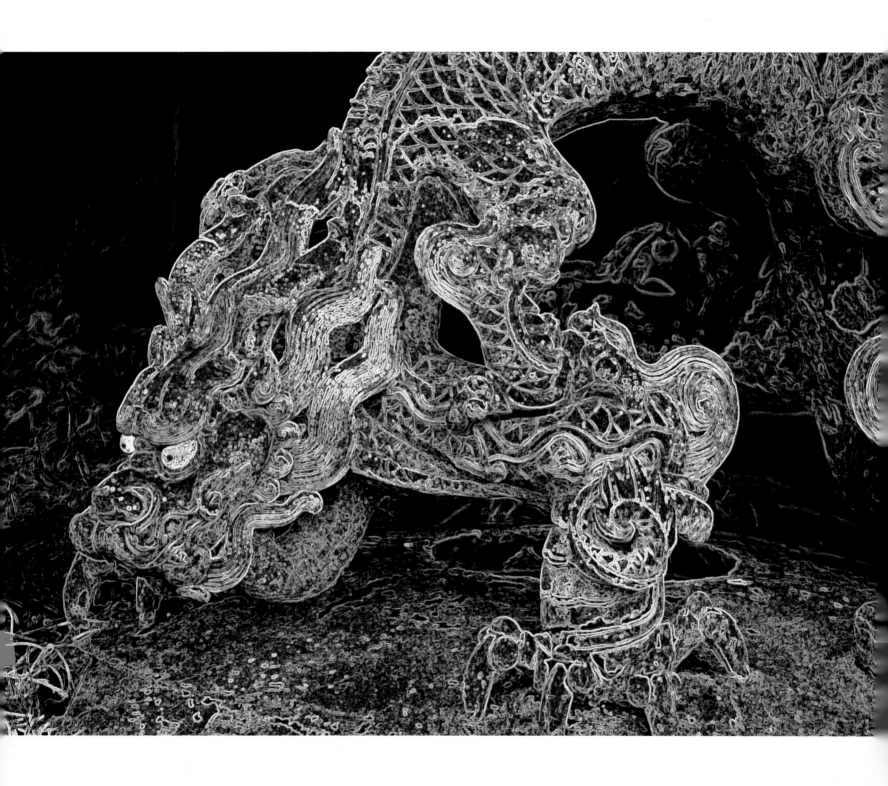

At last the day dawned

when that which the gods desired

had been effected

and what once were koi

had now become majestic

and fearsome dragons!

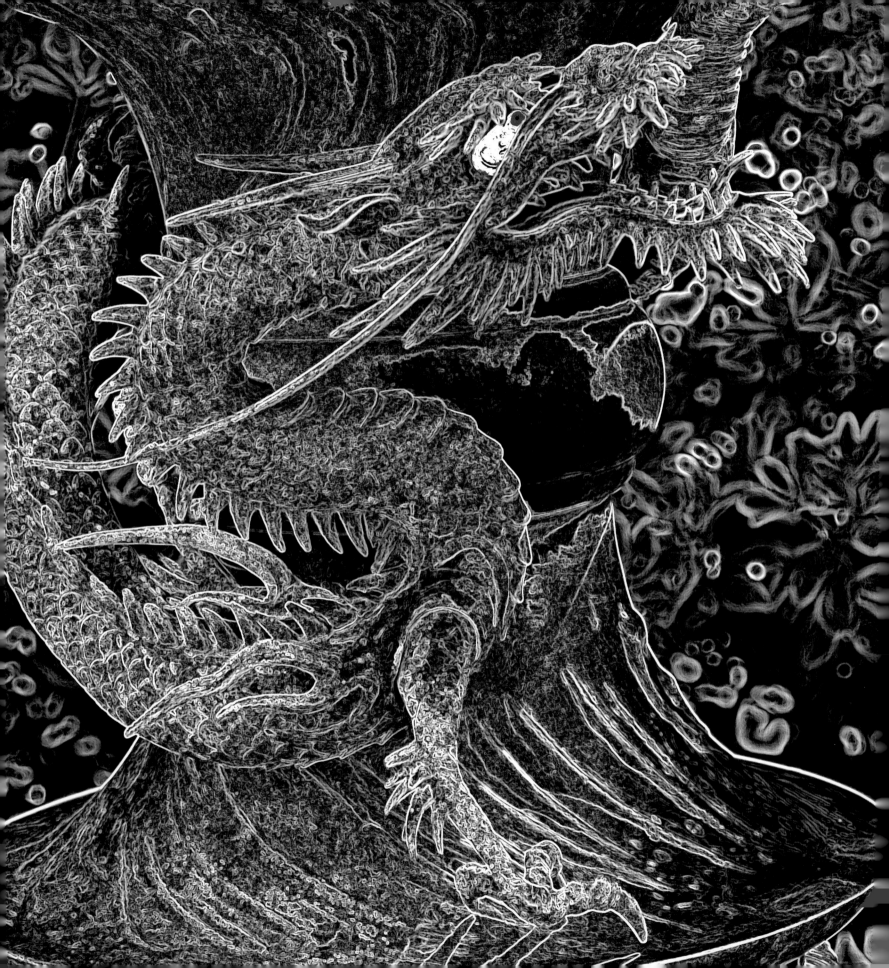

As koi, their calling

had been to bring enchantment

to the human race;

and now, as dragons,

their calling was to protect

and defend mankind.

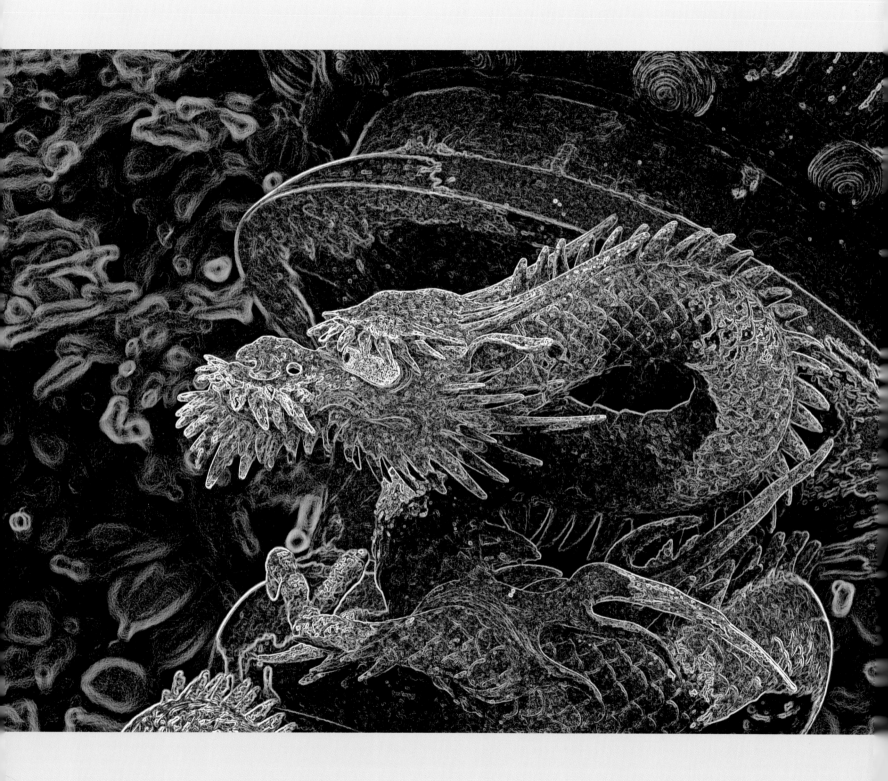

Clearly, there is a

lesson to be learned from the

legend of the koi:

Those who please mankind

will be richly rewarded!

May your inner koi

all become dragons!

LEGENDS OF THE KOI

*K*oi, perhaps because of their remarkable beauty, have inspired a variety of legends. The recurrent theme in these legends is the koi's endurance and perseverance.

One particularly well-known legend tells of a huge school of koi swimming up the Yellow River in China. When they reached a waterfall, many of the koi grew discouraged and turned back. However, a number of koi tried to leap up the waterfall. Local Demons, piqued by the koi's perseverance, increased the height of the waterfall. Still, some koi persisted. And after 100 years, one particularly persistent koi finally made it to the top. The Gods rewarded this

koi by transforming it into a "shiny golden dragon." And whenever

another koi made it to the top, he or she, too, became a dragon.

The legend I invented derives from my own response to the koi's

extraordianry beauty. I felt that the delight we experinece from simply

observing these exquisite creatures was more than enough to earn

them a glorious reward.

SHELDON HARNICK'S career began in the 1950's with songs in revues both on and off Broadway. With Jerry Brock he created a number of memorable musicals including *Fiorello* (Pulitzer Prize, Tony Award), *She Loves Me* (Grammy Award) and *Fiddler on the Roof* (Tony Award, New York Drama Critics Circle Award). Other collaborations: *Rex* (Richard Rogers), *A Wonderful Life* (Joe Raposo), *A Christmas Carol* (Michael Legrand), *Smiling the Boy Fell Dead* (David Baker) and *The Phantom Tollbooth* (with Arnold Black and Norton Juster). He has written two musicals himself: *Dragons* and *Malpractice Makes Perfect*. The Angel recording of *The Merry Widow*, using Mr. Harnick's translation, won the Grammy Award as Best New Opera recording of 1978/79. And along with Jerry Bock he was presented with *The Johnny Mercer Award* by the Songwriters Hall of Fame.

MARGERY HARNICK (known professionally as MARGERY GRAY) began her long career at the age of seven, singing on an NBC-Radio children's program.

On Broadway, Ms. Gray was featured in *Greenwillow* and *Tovarich* (where she played opposite Vivien Leigh and Jean Pierre Aumont). She was also featured in the highly successful Off-Broadway revival of *Anything Goes* and toured the United States and Canada as a principal in the original cast of *The Boy Friend*. Her path crossed with Sheldon Harnick's when she was featured in his shows *Tenderloin* and *Fiorello*. Together they appeared at 'Rainbow and Stars' in 1990. They have created two books composed of her photographs and his poems: *The Outdoor Museum* and *Koi*. (The latter book has additional photographs by their son Matthew.) Both books are published by Beaufort Books.

MATT HARNICK was born in Hollywood but spent most of his life bouncing back and forth between New York City and East Hampton, Long Island. His primary love is natural science but he has always been artistic as well. With a B.A. from LIU Southhampton Campus, he worked as a Scientific Assistant

at the American Museum of Natural History's Department of Ichthyology and Herpetology. In photography he started as a traditional photographer and has both darkroom and digital processing skills. He loves origami and has had several original designs published Origami USA. Professional credits include computer preparation of photos for *The Outdoor Museum: Not Your Usual Images of New York*; photographs for his book *Macy's Thanksgiving Day Parade: A New York Holiday Tradition*; and x-ray of a gecko trapped in amber for the book *Amber: A Window To The Past*.